7 Tools

of the Adversary

Being Aware of his Devices

Written and illustrated by Ned LaMarti

Special thanks

To my beautiful wife Patti

whose love I cherish.

Also, thank you to Kevin Zadai.

When he asked why more books haven't

been written on this subject,

I immediately felt led of the Lord

to take on the challenge.

Introduction

1. Survival
2. Envy
3. Obstruction
4. Fear
5. Misdirection
6. Grudge Match
7. The "Friendly" Ghost
 Conclusion
 Avoiding Contamination

Introduction

Maybe you noticed it. Not everyone is for you. Not everyone is on your side. In fact, a whole underground organization has you on its hit list. Unfortunately, you cannot see them, and chances are you will never see them in this lifetime.

From the time I began drafting this book there has been an extraordinary amount of trouble in life, my family, and my work. I do not, in any way, want to glorify the adversary, but during this time I have been told by several doctors that I have an incurable, life threatening health issue.

In John 16:33, Jesus warned, "You will have trouble on this earth but fear not!" I refuse to have fear. I believe this only proves that the evil ones are panicking and want this work stopped.

The good news is, they only have the power we give them.* If you stay unaware

of their presence, you will most certainly give them the capability of giving you trouble, to say the least. They wish to remain cloaked. This way, the origin of their schemes* will be left up to our imagination. If we are in denial that these enemies exist, we will not have a clue that we are being attacked by them.

The Bible tells us that the very reason the Son of God (Jesus) came on the scene, was to destroy the works of the devil.*

The subtitle, "Being Aware of his Devices" is taken from the writings of Paul who warns we should not be ignorant of such things.*

With tools we can do things that we otherwise have little or no ability to do. They ease struggles on the road to accomplishing goals.

Ephesians 6:11,1 John 3:8, 2, Corinthians 2:11

A simple handcart can give us the ability to move large objects and extremely heavy bundles. A hammer can force a sharp nail into a wooden board with a little bit of effort.

His devices are tools that have been forged for a specific purpose. He is attempting to accomplish an evil work in us with such things. The apostle Paul recognized this and warned us to be aware that these devices will be used on Christians. Looking up the scriptures used throughout this book will fortify you as you see foundational truths found in God's word.

The first thing we need to ask is: What could possibly be the goals that a devil has in mind for a Christian? If we understand this, these devices will become more evident when they are used in our lives as well as the lives of those around us. Their desire is to keep the Lord away from you.*

* Ezekial 8:6

They know God will not tolerate sin. If they are successful in keeping you in sin, they can keep God from being a part of your life, the way He wants to be. The demons want to be involved in your life. They desire to have you accept their input.

When Adam and Eve ate of the tree of the knowledge of good and evil that is exactly what happened to them and now us. Imagine your mind only thinking about things that are good! The action they took (eating that "particular" fruit) totally opened their minds to the spiritual aspect of this world. This allowed anything and everything in that dimension to have unlimited access.

We are now the only ones in charge of what we are accepting. We have power from The Holy Spirit to set limitations and control how far the enemy can infiltrate. If a mosquito lands on your arm, you will immediately swipe it away as soon as you realize its presence. The way to guard our

soul and body is to be constantly watching, praying, and being aware of any intruders. If we do not understand the power and authority that has been given to us, we will be subject to whatever wants to have its way with us. We would be victims. Traps are regularly being set for us.*

In the next few chapters I will present seven tools I believe are the most common and dangerous.

* 2 Timothy 2:26

Tool Number 1

Survival

They are afraid. They know we have the power to relocate them. We can remove them from their place of influence and send them to places that are very uncomfortable for them.* They also know their ultimate end, in the lake of fire, and they have no idea of when that might happen.

The mere fact that you enter a room where an unclean spirit might be attached to someone may cause some discomfort for the person ensnared. An influenced person might become irritated at your arrival because the demon is irritated and projecting its feelings on its victimized subject. Jesus told us not to be surprised when people hate us.* For no for apparent reason a person you just met might dislike you. You ask yourself, " What did I do?"

*Luke 11:24, Matthew 25:41

The hate filled person may not even know why they feel that way about you. This self-sabotaging relationship happens when a hiding demon tries to temporarily protect itself and its home.

The person may go into a very shy state or even into stupor. This is a way for the devil to keep from exposing itself, hoping you are unaware of its presence. The other extreme would be for the person to act irrationally. They may get angry, begin shouting, resort to name calling, or violent actions. In this case it is trying to put you in a fearful state in hopes that it renders you powerless in fear. Obviously the most physically dangerous is violence.

The attempt to protect their habitation could end up becoming very dangerous. I once had a man pick up a chair, raising it over his head and start to run toward me while I was ministering music at a meeting. (I don't think it was because I was out of key.) He was subdued by two pastors

before he reached the platform. He was "reminded" of the authority that Jesus has given us and put into a calm state almost immediately. When the intruder is found out and its presence is obvious, we should know that we are not powerless. Now it is at our discretion whether we think it is in the person's best interest for us to act. Just because there is a demon present, it doesn't mean we are to cast it out.

Jesus warns us that it could put the delivered person into a worse condition than before.* Instruction about how a person should keep themselves from being demonized again is important. On the other hand, the devil's do not know what you are going to do. They found a place of comfort and are worried about losing it.

Once the demon is cast out, the delivered person needs to avoid having it re-enter, with reinforcements. This isn't always as easy as it sounds.

*Matthew 12:44,45

This thing has positioned itself into a body or mind and has become familiar and accustomed to the habitation. The victimized person may feel comfortable with its presence and even enjoy certain aspects of its characteristics. They may even display certain personality traits the demon presents. Resisting could be difficult and introduce a feeling like they are betraying a friend.

It is important to understand that the demon is not anyone's friend and is only interested in killing, stealing, and destroying its host as well as any available bystanders.

Sometimes there is a feeling of empowerment that comes with demonization. This power cannot be relied upon. It is only there to enslave its host and become a necessity to survival. False courage comes built on evil hostility. The degrading of others is usually involved. This

falsely raises the fabricated self-image to higher levels.* Someone who wants to continue being proud and arrogant will not be a good candidate for deliverance. Their behavior will only make things worse. Distancing yourself from this kind of a person is usually the best remedy. God resists the proud and draws near the humble.

*Philippians 2:3, James 4:6

Tool Number 2

Envy

It is very important for us to understand the motivation behind the demon. They are empowered by envy. It drives them. They hate the fact that God has placed us in a higher state than them. The authority we have over them and in the world is something they want to keep hidden from us. Jesus said we (us) could have what we say if we believe.* The devil believes this even if you don't. In fact, it's better for them if you don't. You can make their job a lot easier if they can get you to say things in vain. Many people think it is ok to say whatever pops into their mind without any repercussions. But Jesus said we will be judged forever idle word we speak.*

Meaningless words will begin to carry some weight if they are repeated enough. Faith comes by hearing and hearing* and so does fear if you let it. The book of Proverbs has a lot to say about talking without thinking.

*Mark 11:23, *Mark 12:36, *Romans 10:17

If you are willing to speak out a thought without considering where it came from, you are a candidate to become the devil's next victim. Many of our sayings have a negative overtone for this very reason. I cringe when I hear Christians say things like, "This is killing me!" or "I just can't win!"

The demons love to tell us to say phrases contrary to what the Bible says about us. They persuade us to talk like this because they want us to self-destruct. They have no greater desire for you than to see you fail. We are told to judge every spirit.* Spirits talk. They may come as a thought or use a person to talk to you. Those words need to be weighed and judged according to the Word of God. Are they saying what God says? Is what you are saying consistent with God's plan for you? If it carries fear, we know that God has not given us a spirit of fear.*

*John 4:1, 2, Tim. 1:7

Demons want you to be afraid. When you are afraid, you aren't trusting God. Repeating and meditating on fearful phrases is the same as coming into agreement with their evil purposes and plans for you.

Contrary to popular thought, just because a person is a Christian doesn't mean the devil cannot use them. As a Christian, your spirit is reborn, made new with incorruptible seed.* Our soul, on the other hand is being saved. The mind is to be renewed while we are living here on earth.* Ultimately, we will get our new bodies at resurrection. Therefore, our body and mind is still subject to the influence of the demonic. That is why the Bible tells us to RESIST the devil.* The word "possessed" implies ownership. We cannot be possessed by anyone or anything if God owns us.

*1 Pet. 1:23, Rom. 12:2, James 4:7

That didn't stop satan from talking to Jesus and trying to get Him to sin.* I'm sure you don't want to be used by a devil and neither do I. But a meaningful Christian may tell you something with the best of intentions and it could still be as effective as a satanic curse. If a person tells you that something terrible is going to happen to you, you still have the opportunity to reject the idea according to God's word.

Speaking out Scripture contrary to the proposed curse will allow Angels to move on your behalf. They can reverse a process that has already begun in another dimension and bring into fruition God's plan for you.* In the same way, agreeing with the curse allows demons to move and get things situated to bring the curse to pass. Reacting in fear IS agreement.

*Matt. 4:1-11, Jeremiah 29:11

Reacting in faith is using your shield to extinguish fiery darts* and holding on to the promises of God in His word.*

A good example of this is found in the Gospel of Mark 8:32-36. Jesus was telling His disciples of the kind of death He was about to go through. Peter took Jesus aside and sharply disagreed with the idea. The interesting thing here is Jesus turned His back to Peter and faced His disciples saying; " Get behind me satan!"

Peter was used (unsuccessfully) by satan. He was probably well meaning and thinking what he thought was best for Jesus. Unknowingly, he became a tool of the devil. Peter was one of Jesus' closest friends. If he had understood God's plan for salvation, he would have been able to weigh the words that were coming into his mind and compare them to the truth.

*Ephesians 6:16, Hebrews 10:23

After seeing the exhortation agreed with God's plan, he could have stopped himself from saying the words that got him in trouble. So, speaking out of a feeling of compassion does not necessarily mean it is of God. Our feelings are not always good indicators of what is right and true. We position ourselves for misdirection if we lack understanding in the Word of God and His promises available to us.

Since devils are envious, when you feel envy or think of a reason to be envious, you are being tempted to receive what the devil has for you. Our flesh still has these earthly characteristics that the devil can cater to. Our mind may pick up on some of these feelings and try to discern a possible "right" to feel that way.* Our mind then is presented with a choice to justify our feelings of envy or surrender to the will of God that tells us not to be envious.

* *1Peter 2:1, Proverbs 3:31-32, 14:30, 23:17, James 3:16

This series of steps can be applied to every feeling that we have. Envy opens the door to many other problems.*

Long ago, in an extreme case, Eve was tempted to be envious of God. Once she decided to accept the idea that God was keeping her from some higher state, she separated herself from God. Envy and jealousy are dividers. They set Christians against each other and remove any act of love. If we can be divided so easily, we can be conquered. Know that the driving power behind separating Christians is not God's Holy Spirit. God is love.* His empowerment will move you in a loving direction.

Jesus said they should know us by our love for one another.* That means we are then separated to God, sanctified, set apart for Him.

*John 4:16, John 13:34,35, John 13:14-17

This won't happen if we are glorifying ourselves. Jesus put on a towel and washed the feet of His disciples* to show the fashion in which Christians should be treating each other.

He said the least among you will be the greatest.* This is the contrary to what our natural tendencies want to demonstrate. There are those who will even encourage us to take the position of power in the flesh and subject ourselves to the worldly standard. They say things like, "Stick up for yourself, Look out for number one". Weighing these thoughts and looking to the Word of God for our final decision is the best way to stay out of the enemy's grip.

*Matthew 23:11

Tool Number 3

Obstruction

Devils want to stop Christians from multiplying. What I mean by that is, Christians reproducing Christians. You, training someone to be a disciple of Christ is something that devils are afraid of. This means more danger for them. If you are seen doing anything to promote Christianity, there is probably going to be a target on your back. This by no means should slow you down because, "Greater is He that is in you (the Holy Spirit) than he that is in the world."* People that are in the spotlight and especially those that are good role models may be attacked on a larger scale than those behind the scenes. Everyone who is planning to make a difference by spreading the Gospel is subject to attacks. Nevertheless, being effective in the business of making disciples should be a number one priority for Christians. The devil's impact on society is greatly reduced when he is brought to light.

*1 John 4:4

Once the presence of the devil's work is discovered it can be avoided and resisted.*

The more people learn about the troublemakers' acts, the less impact it can have on people. The devil's do not want anyone to grow in Christ. When this type of growth happens to us, we become more aware of the demonic activity that is all around us. If he is found out, he is in a dangerous position and loses much of his ability to function.

No wonder Jesus said, " The thief comes to steal, kill, and destroy."* He made it easy for us to place an emphasis on the three things that the troublemakers come to do. More importantly are the three words that Jesus begins with. "The thief comes..." Jesus made it clear that the thief WILL come. In our world today, there is a train of thought that says there is little or no demonic activity around us.

*James 4:7, John 10:10

This thinking that a devil having an impact on someone's life is a strange thing or only happens in remote areas of the world is simply untrue.

The last thing I would want to do is to put fear in you, but God wants us to be aware of what is around us. He told us this to prepare us for a dangerous world. Our expected response to this trouble is supposed to be "Cheer up!"* Jesus believed there was reason to celebrate since He has already overcome the world. Jesus understood that by His accomplishments at the cross, He had given us the power over this enemy. There is no reason to fear. Now we can make life easier for ourselves and others by dealing with the source of our problems. We have the power to do it!* Jesus has successfully inducted those who believe in Him to have special rights in the spiritual realm.

*John 16:33, James 4:7

The devil is called a thief because he is breaking and entering. He is a trespasser. The enemy likes to work from the inside. because our mind is in another dimension. He has a voice there illegally. His access to what we call reality or the real world is out of bounds for him.

His duty is to work from this other realm to cause a reaction in us and make it a physical reality. They know that the spirit is foundational to the flesh. He cannot be effective in the world without our involvement. Our participation in his plan is sin. Since he is there illegally, he must be rejected and pushed away. We can be defiled by what comes out of our mouth* only because we partake in his discussion. Devils are continually trying to get you involved in the plan to kill, steal, and destroy something or someone.

* Matt 15:11-20

It is always good to keep a constant awareness of what your motives are for saying and doing things. In some cases the motivation and goal may not be your own. Keeping God in mind at every turn and considering His word with every move holds great reward for us.* If we stay on the road set before us and avoid veering off to the left or the right, God promises to guide us in the most prosperous way. The right direction will be made obvious for us. The path we are to take will become lit up before us.*

All of the schemes of the enemy are founded in our lack of understanding our position. This void gives the devil a place in which to begin work. The open area where the Word of God is missing is a potential home for the adversary. *

*Proverbs 3:5-7, Psalm 119:105, Eph 4:27

He will try to find out where you are lacking understanding in your position in Christ. If we are moving in our own pride and not resting in His promises, we are vulnerable. This is where he can set up his workshop. He is listening to what you say and looks to find where you are in error of the Scriptures. That is why taking on the responsibility of being a teacher of the Word can bring more trouble than necessary.* Being unsure of the scriptures isn't terrible unless you act like you know what you're talking about when you really don't. We can only believe what we think is true. Demons have been around a long time and know the Bible because they are continually looking for ways to discredit it. If you are questioning something about the word, ask God, ask someone who you respect as a Christian, or even better, start studying.

* James 3:1

Tool Number 4

Fear

I believe this to be the devil's most effective tool. Maybe you hear an unexplainable sound or something in the room moves for no reason. Devils can be empowered by our fears. Not unlike faith, believing that something evil is going to happen to us is fear. That doesn't mean we shouldn't be careful to make good judgements. When we walk across the street, we still look both ways first. But still, we shouldn't be looking at every circumstance in our lives and thinking that the worst-case scenario is inevitable.

Being fearful is a learned practice. Scary movies seem harmless, but they are fear builders that give strength to our enemies helping them to produce more destruction in our lives. A bad experience playing over and over in our minds can do damage. These false experiences give credence to what manner of evil becomes a possibility for us.

Jesus said all things are possible for those who believe.* That statement can be looked at in both directions. Many avoid very constructive undertakings because they have already decided an injurious outcome was inevitable.

Former President, Franklin D Roosevelt is known for making the great statement, "There is nothing to fear but fear itself." He must have felt the country was unnecessarily falling into the grip of fear. He was saying we should be afraid to fear. Fear is real, and it is a spiritual force. Its assignment is to kill, steal, and destroy.

God says it is considered a treasure for us to fear Him.* If that is our priority, we have nothing else to fear. He wants what is best for us. When God is in the highest place possible, no other entity or situation can have any power to scare us. It is our choice whether or not to give those other things any power at all.*

*Mark 9:23, Isaiah 33:6, Matthew 10:28

The devil wants you to be afraid. He will try to find ways to steal your peace. He will watch to see what might give you a scare and build on that. Speaking out your fears to others gives devils information that is valuable for them. This only results in an opportunity to bring those situations to pass in life. Your words might become the permission the enemy is waiting for. One who is in fear is not of a sound mind.* This kind of fear doesn't come from God. It comes from a living spirit that is illegally interacting with you.

Accepting fear and indulging in it can bring an atmosphere of panic and confusion. This creates a workplace for the devil to organize danger. Feelings may react in our body from fear without permission as an involuntary impulse simply from hearing or seeing something.

*2 Timothy 1:7

Our mind must take control and resist, stopping any further reaction that will deepen the entrapment. The situation can be reversed by the power of the Word of God to help us.

David spoke to his soul (emotions, feelings, and thought life) asking it, why it was so downcast.* He didn't think it was appropriate to feel that way.

In most cases speaking God's Word out loud will stop the devil and bring peace to our flesh. How can you be sure you don't have to be afraid? What does God say about it? Has God given you this feeling? Search the Scriptures to find out how the Sword of the Spirit can help you.

Fear and trepidation stem from our lack of knowledge. When we fail to understand how much God loves us, we can become unsure of our safety. If we are tormented by the feeling, we can be sure it is not from God.*

*Psalm 43:5, 1 John 4:18

God has already provided a way of escape. God is for you and not against you.* Believing that; is enough to cast away all fears. Physical feeling cannot be the determination of truth.

This fear began in the spiritual realm, and it can only be defeated in that arena. You will notice the feelings subsiding when you take control in the spiritual realm by speaking the Truth, which is the Word of God. Just because you don't feel it, doesn't mean it's not Truth. Our feelings do not determine Truth, God's Word does.

*Romans 8:31

Tool Number 5

Misdirection

Most magicians will depend on their ability to get you to focus your attention in a certain direction. This way they can do the "real work" in a place you aren't aware of. Then, when they are ready, they will have you look at what has changed without your noticing. Poof! Everything is different. The magician has successfully "fooled" us. Many times, we assume we are in control and aware of all our surroundings. It makes us feel good to think we are in command of our situation and handling things properly. When we are misdirected, we are thrown off balance.

For instance, what is it that makes us want to complete an unfinished work? I have a friend who plays piano. If I would start off that little tune on my bass, *"bum badda bum bum,"* he would have to finish it, *"bum bum"*! He couldn't help himself. Unfinished is not tidy.

A lot of us want to have everything in our view symmetrical. If we can straighten

something out, finish something, or color coordinate someone, we feel better. This is a big job we are taking on! The opportunities to make adjustments are going to be never-ending. Our assessment of a situation may not be what is really needed at the time. Unless you are a quality control manager in a factory, correcting or tweaking every matter in front of you is not always called for. It will definitely keep you busy but it doesn't mean you are on the right path.*

Are we afraid that we are expected to be doing something? We might be on an anxiety driven trail filled with undue stress and trouble. If we do it without consulting God, how will we know it is even necessary? He wants to be acknowledged in all our ways. * The devils want us to be busy doing things that do not matter and keep us from doing the things that do.

*Luke 10:41-42, Proverbs 3:6

The Bible calls this foolishness. Many plans are made without the consent of our Heavenly Father.* Whether a plan seems successful, or it looks like it has failed can only be judged by God. That which is approved by God is right and truly successful, no matter what it may look like to us.

Merely doing something just because the opportunity is there is foolishness. Many times, I wish I had stopped myself from saying something funny just because the was a good opening for a joke. Only later to regret having done so.

Completing a task is very rewarding. The harder the task the more rewarding it is. Jesus said sometimes there will be those who already have their reward.* This was suggesting that the reward they were getting was not the best available (from God).

*Proverbs 19:21, Matthew 6:2-5

We can accomplish things for ourselves or for God. When it is solely for our own gratification, that is all we have the chance to get from it. If we act agreeing with what God has in mind the return is much greater. God is productive and does not waste anything.

The devils' involvement here is to get you to think in accordance with his plan. Ultimately, it will be about the flesh and what seems best for you and you alone. He wants you to end up at a certain

conclusion in your thinking. It will guide you through a course of thought. But first he must get you to "bite".

Something you see, hear, or encounter might trigger a thought. The devils need help. They have no ability to create so they utilize whatever is available at the time. It is a good thing to ask yourself why you have a thought in the first place. The adversary needs a springboard or launching pad to use to break into your mind.

God has the ability to speak to you without any other influence. He is almighty and above all. Remember, Jesus said the Kingdom of God does not come by observation.*

When we look for things in the world around us to get messages from God we are playing with fire. This is the way of witchcraft. They will use cards, the constellations (astrology), crystals, and many other semi-reliable articles to predict and provide what they would call wisdom.

These ways are a path leading to death. Jesus said it is a wicked and adulterous generation that looks for a sign.* It may seem harmless, but the result is only trouble. This is difficult for many Christians to accept because it is so apparent that God works in our life here on earth and we can often see His hand in things affecting us.

*Luke 17:20,21

Someone told me once, "Christians don't follow signs, signs follow Christians."

The problem occurs when we seek out God's instruction through the things of this world.* God is quite capable of speaking to you without help from anyone or anything.

The devils need your approval to continue a conversation in your mind. Even though it may start out looking very innocent, the only purpose they have is to lead you into destruction, steal from you or kill you.* Satan's approach to Eve, in the garden, was with a seemingly harmless question: Did God say?...*

Apparently, the serpent already knew what God said. His strategy was to get Eve to enter a conversation with him. This way he would have an opportunity to get her to question God's love for her and ultimately, kill her.

*Matthew 16:4, 1 John 2:15, John 10:10, Genesis 3:1

If the devil is successful in getting you engaged in a question-and-answer dialog, it can lead you into a direction that you are not wanting or expecting. The devil will always offer to help draw conclusions at this point that will not agree with the Word of God. Deception is weaved subtly into the conversation contaminating the truth unnoticeably. Soon, one is doubting him or herself and in danger of becoming a victim. Even though God's name was involved in Eve's case, her foundation was weak. The motivation for the conversation was based on deception and the insinuation that God should be judged and not trusted.

You may have also noticed symbols or logos that look purposely unfinished. Possibly, one more line or curve added to it would easily complete it and it is left out of the finished product. This is a technique often used in advertising because the seller would like you to continue thinking about

their product for as long as possible. In most cases, it looks just enough like something familiar to try and make you guess what it is. They hint at a deeper meaning than what is obvious. Later, a thought could pop into your mind relevant to that image you spotted earlier. The idea is to get your attention and hold it. This could be a distraction keeping you from what you are supposed to be focusing on.

Almost always, there will be a commercial break before a game show announces the winner. Television programming, movies, and books are notorious for keeping us on the edge of our seats and leaving things unfinished, so we are "dying" to find out what happens next. The season's final episode always leaves us with the most unanswered questions. There will always be another episode, sequel, or even a game that is more important than the last to try and steal a segment of our precious time from us.

This system is used in art, sales, all types of media, and architectural design. Much of it is innocent and designed to carry your thoughts in a certain direction, hoping to keep you interested.

There is however a grey area that muddies and it becomes dark. To connect themselves to us, devils love to use symbols, objects that symbolize something, and even people. They attach themselves to one of these and lie in wait like a fisherman or a hunter setting a trap. This is something to think about since symbolism is becoming such a factor in our society today with tattoos, computer games, and car stickers.

Many of us are symbolizing ourselves now with avatars. These manufactured images always represent something or someone. People can now simulate experiences that feel very real. What was once only depicted in futuristic, science fiction movies and books have now become reality.

Movie stars, musical artists, and sports figures are widely considered worthy to be worshipped. They are appropriately named idols. The mouse should ask himself why the cheese is so prominently displayed on the spring loaded piece of wood before he decides to indulge. I'm not saying that you should never indulge in any of these things but please be aware that they are in the business of making money and they think you are the one who will help them to make a profit. A Christian should know there are traps set everywhere for him or her.

In the last days, the devil will want everyone to worship his image.* It is written that this image will be given "Life". It could be that it is a fabricated object that is given a mind of its own. Maybe AI? The effect that this image has on people could lead them to an eternal death.

*Rev.13:15

The devils are continually battling for our minds. In King James vernacular that is our "souls". The part of us that needs to be renewed* is being attacked to stop that renewal process God has begun in us. If we are in awe of technology and the advancements that have taken place in the last few years, we could find ourselves in a dangerous position.* Their way of thinking is designed to move us toward self and away from God.

Most Christians refuse believe they are important enough for demons to bother with them. They think they can skate through life unseen and doing something for God occasionally, without being harassed. The devil goes around seeking who he MAY devour.* He is constantly asking us if he may devour us. We are told by the apostle Paul to walk circumspectly.*

* Romans 12:2, Matthew 24:1,2, 1 Peter 5:8, Ephesians 5:15,17

That is to be aware. Aware of what? Later in that chapter he says, "because the days are evil." We are to be aware of the opportunities to do what is good and right but also that there are many opportunities to make foolish decisions, wasting time and energy on the wrong things. The best thing to do is to sit at the feet of Jesus.* Worshipping Him and meditating on His word is never going to be considered wasted time.

No matter how smart man becomes, he will never be close to being as smart as God*. The world's technology is always trying to get everyone's attention because there is money in numbers.

People are making a living out of social media. The more people you get to follow you, the more money you can make.

<div style="text-align: center;">Luke 10:42, Isaiah 55:8,9</div>

It isn't all bad but a lot of what happens in the computer world is destined for destruction.

Take a dollar bill out of your wallet or purse, if you are someone who still carries cash around. The reverse side shows an unfinished pyramid displayed. It draws our eye to its missing peak. There you will find an "eye" staring back at you.

Tool Number 6

Grudge Match

The major characteristic of the "grudge tool" is the devil's voice. Jesus said His sheep hear His voice.* He also had the ability to hear or know what people were thinking.* Communication with our voice is as much a spiritual thing as it is a physical thing.

In a dream I was caught up in the heavenlies. I found myself in a large open area where everyone was walking in the same direction. I remember talking to people around me and they would respond without moving their lips. I thought this was very odd but when I had a thought, they also heard it and were able to respond accordingly. Isn't it a good thing that doesn't happen here? The reason it is allowable to happen in Heaven is because of the devil's absence. Without his input there is no danger of anyone getting hurt.

*John10:27, * Matthew 9:4

There is voicing in the spiritual realm. It is engagement in another dimension. One that we are not always aware of. Even though we are all very busy in this realm, we don't give it much weight. When we speak aloud, we are meshing with this other dimension. Many refuse to believe this is possible.

The truth is, we will give account for all that we say.* The demons know this is true so they take advantage of it. They also realize that if you don't believe it is possible, you will think it is "just your mind" whenever a thought comes. This will prevent you from hearing Gods voice. It will also put you in a place where you can say things that correspond with thoughts you are having, whether they are of God or not. Holding a grudge against someone will not affect them as much as it does you.

*Matthew 12:36

The devil's tactic is him speaking to your mind in the first person. It may say "This would be great for me" or "I really need this." He will be diligent to remind you of how a person hurt you and got away with it. Acting on or complaining about the issue will cause more trouble and open you up to worse attacks. Deception happens when you

take responsibility for thinking such a thing. Somehow, we think the thought will keep pestering us until we do something about it. By blaming yourself for having the thought, you lower your confidence, decreasing your power and ability to work at the level of authority the Lord has given you.

Many have placed themselves in bondage by failing to accept the fact that God has already dealt with the contamination of sin in our flesh. The burden is too heavy for anyone to bear.

Christ has overcome by giving us His Holy Spirit.* When someone offends you, the devil's that are in the vicinity are most likely aware of the opportunity. They are bent on putting you in the bondage of unforgiveness. God has said how important it is to forgive those who hurt you. We must forgive so the Father CAN forgive us.* We have to believe the Father forgives us. How can we forgive if we don't think we are forgiven?

How can we believe if we aren't willing to forgive ourselves? If we say it depends on how bad the offense is then we put limitations on what the Father will forgive. We will have a hard time believing we can be forgiven for our offences. Forgiveness means not repaying evil for evil.* Even the slightest repayment for evil shows unforgiveness. A reaction, a word, or even a look can display vengeance.

*Romans 8:9, Matthew 6:14, 1 Thess. 5:15

Devils love to remind us of past hurts. They want us to replay them in our minds over and over again. If we realize this, we will know to resist it. When the thought comes. "That's the guy that hurt me!" We need to put that thought under arrest.* In order to do that we have to separate ourselves from the thought. We cannot take responsibility for thinking it. Most importantly, we should not accept it, by adding to it or indulging in it. Cast it down!* Speak God's word over the thought even as it is coming in.

Speak out the reason you believe God doesn't like it. That's how Jesus handled the devil.*The devil is a liar and has no problem trying to get you to believe you are thinking something bad. He wants to drive you into self-condemnation.* If you are in Christ, you are sanctified. God separated you to Himself.

* Lamentation 3:62, 2 Corinthians 10:5, Matthew 4:1-11, Romans 8:1

He set you apart from sin so He could live in you. We need to recognize sin and believe we are separated from it.* We do not have to indulge in it or take part in it, no matter what we are feeling. The mind of our flesh might desire the satisfaction of vengeance, and this is the flesh. We are not to walk in the flesh but live according to the Spirit.* If we arrest the thought and speak the appropriate scripture, the feelings will soon follow suit.

We show our disapproval of it. Our perfect, born-again spirit already disapproves and wants our body and mind to agree with him. This is the proper way to keep our flesh in submission while renewing our minds. There is no need to feel condemned just because our flesh has certain feelings. Everything must bow to the Word of God.

* John17:19, 2 Cor. 10:3

"Look at that person over there. You've got to be kidding with that outfit. Who wears something like that?"

Would you indulge that conversation? Where did it come from? It may have just been a thought coming into your mind or another person might have spoken it audibly to you. Nevertheless, it came from the pit. Criticism that cuts people down is a characteristic of pride and does not come from the Father but from the world.* In an effort to build ourselves up we are tempted to elevate ourselves above others by pushing them down. The demons want us to take pride in our possessions, designer goods, trends, and status symbols.

This puts us in a competitive state of mind that degrades and inaccurately judges God's servants.

*1 John 2:16

Having good things is ok but we shouldn't use them to grade ourselves above others. We are not to think of ourselves too highly.* We are all precious in God's sight and love always thinks the best.*There is constructive criticism which has the intention of building one up and helping to show ways of improvement. There is also healthy self-criticism. Being honest with ourselves and finding a better path in our own journey.

There is also a criticism that derives from hateful thoughts. It attempts to involve our body's voice by name calling. This is a way of categorizing people to make them appear lower than ourselves. Dividing human beings into different levels is nothing more than an image in the mind. It isn't real. God loves everyone equally and wants us to treat everyone fairly and without discrimination *

*Romans 12:3, James 2:1-4

It isn't God's plan for Christians to be divided amongst themselves. People seem to be drawn to grouping themselves with others in the same category, whether it be color, traditions, nationality, or scholastic achievement. This is a major problem in the church. Devils love to divide us. Our unity in the faith* should be a high priority. Our power is multiplied when we come into an agreement.* It stands to reason the our power would diminish when we are separated.

Hate is an emotion but it can also be sin.* Jesus said we should be known by our love for one another.* Demons will give you plenty of reasons to hate someone. They will never give you a reason to show love. That right there, should help you to understand where the feeling is coming from.

*Ephesians 4:13, Matthew 18:19, 1 John 2:11, John 13:35

Loving people doesn't mean you have to agree with everybody on every subject.

It does mean that we should be caring about their wellbeing. It doesn't have to be a feeling or emotion.

It is an action. It could also be the lack of action. When we see a lot of people moving in the wrong direction and doing hateful things, we need to be able to separate ourselves from the crowd. It's time to forget about what the richest, most cultured, highly educated, or whatever category that considers themselves above everyone else and walk the love walk.* Unity needs to be based on love. God is love.* If we walk in love, we walk with God.

* Eph. 5:2, 1John 4:8, John 14:26

When that particular person you know, walks into the room and the thought comes to you, "I can't stand him!" Yes, you can! Yes, you can! The Bible says you can!

The Holy Spirit within us promises to remind us of the things we have heard and read in the Word of God. I can do all things through Christ who strengthens me.* My God always causes me to triumph.* I let all bitterness, wrath, anger, clamor, and evil speaking, be put away from me, with all malice: and I am kind, tenderhearted, and forgiving, even as God, for Christ's sake, has forgiven me.* Resist* with the powerful Word of God and send the enemy fleeing.

*Phi. 4:13, 2 Cor 2:14, Eph.4:31, James 4:7

Tool Number 7

The "Friendly" Ghost

Like most kids in my day, I grew up with comic books and cartoons. Being so young, I failed to see the indoctrination that was happening through the images and stories directed toward myself and other children. There were cute and friendly devils, witches, and ghosts being introduced to us. Sure, we believed in scary stuff that might be lurking under the bed or in the closet, but here was something that could be worth checking into.

We became aware of the possibility of having a friend who was gifted with supernatural powers. Initially, we were taught only to associate these powers with God (Who didn't seem to be around) along with that, some kind of dangerous sorcery, or evil spirit. The idea of having a "not so evil" companion, like these magazines and programs suggested, could be a handy lifestyle for a kid to embrace. That is just what a lot of us did. Some of us even had imaginary friends. We looked for supernatural inroads so we might

somehow secure an upper hand among our friends and our enemies. This fascination with the world of the paranormal for the young has not slowed down a bit. Today we can easily see how the dark world has become more apparent and acceptable in all media.

Books regarding training in the occult are flying off the shelves while movies and television programming is filled with apparitions, vampires, and magic and the Bible is taking a back seat. You could think dabbling in this stuff is harmless. That's exactly what they want you to think. Is it really harmless? Could we enter into it on a light scale without going overboard? The answer to that is an emphatic NO! There is no good reason to put a little poison in your drinking water. Not even a drop!

The Bible tells us NOT to give place to the devil.* We shouldn't give any dark entity a

*Ephesians.4:27

reason to believe we want to be acquainted with it in any way. Remember, they are here illegally and only come around for three reasons, to kill, steal, or destroy.*

If you want to indulge in the supernatural read the Gospels to see how Jesus trained His disciples to become powerful men and women of God. He said we will be able to perform greater miracles than He did if we adhere to His Words.*

This devilish tool of trying to convince people that demonic activity is acceptable in today's world. It is fed to our young as though it is something new. The innocence of the child is taken advantage of because the parents have been deceived previously.

How we decide to deal with the dilemma of the Halloween "holiday" is becoming more and more complicated for sincere Christian families. Some declare it is quickly

*John 10:10, John 14:12

becoming more popularly celebrated than Christmas in America. Halloween is now a designated season to see morbid displays of mutilated figures and bloody, grotesque scenes on front lawns of homes around the nation.

Light shows and moving plastic, blowup statues alongside gravestones and spider webs fill the landscaping of houses across our streets and neighborhoods. The spirit of fear is promoted and rewarded as a good thing during this season. Animated displays and people dressed up accordingly are rated on how much fear they can produce in their victims. Even the youngest of children are not exempt from being startled as they approach any doorstep.

When groups of people get into the same mental state, there is a feeling of power. Much like the Christian experience in the fellowship of believers, where there is an anointing of God. The same principle applies when the demonic influence

crosses over into the hearts of the masses. This is how rioting and looting occurs. People will do things that they normally would not do when they get caught up in the "spirit" of things. Somehow, actions that were previously deemed as wrong, suddenly become acceptable.

We cannot forget that the devils are in another realm. Operating outside of our 3 dimensions, they have different limitations than we do. Behind the scenes they can work without our observation. Whatever we do in this world, they can see and what they do, we cannot see. This gives them some advantages that many Christians fail to take seriously.

Underestimating the abilities of the enemy is always a mistake. We need to be aware of the capabilities of our adversary.* The enemy has most likely been watching our actions and responses for a long time.

*Matt. 25:41

It is possible that he is calculating our probable movements with some accuracy. It stands to reason, if we allow him, he can also make moves to trigger our reactions successfully. He will look for whatever scares you or gets you mad and provide it for you.

The devil is not going to bring you joy and peace. He's going to figure out how to get negative responses from you so he can begin to destroy your character and poison your relationships. After he is successful in bringing you to a boiling point, he will not pass up the opportunity to dispense the shame and guilt to make you feel as bad about yourself as humanly possible.

If the demon is allowed to do these things, it will guide you to a place where you won't feel worthy to live. Self-destruction is its goal for you.

When we make a seemingly small and insignificant aspect of evil acceptable, we are introducing contamination into our

system. Jesus talked about how a little leaven causes a great impact on bread. He was relating to the sin of His adversaries.* If we detect anything that resembles sin in our lives we must get rid of it.* Reject it, because it did not come from our new nature. It is our own flesh that is opposing us. The desires of the flesh are always trying to dictate how we live our lives. Our new, Born-Again spirit is clean and trying to set the pace for our mind and body. The righteous path is lit up before us as we walk in the Spirit.* Walking this way is merely looking to do the right thing and acknowledging God in our ways.* Exclude the evil and include God.

*Mark 8:15, James 1:23, Proverbs 4:18, Proverbs 3:5,6

Conclusion

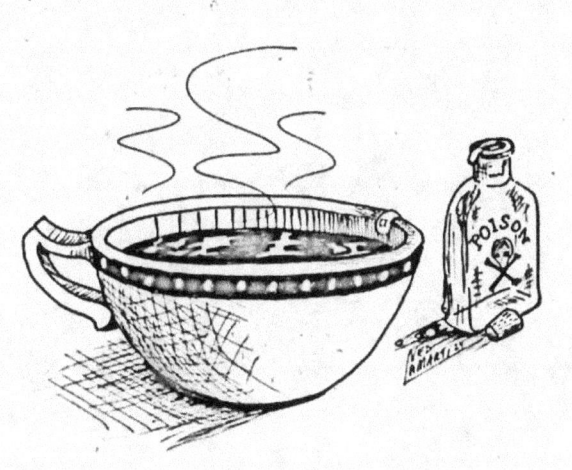

Avoiding Contamination

In recent days, it has become important to a lot of people to buy organic foods and whole foods. Natural food stores have become more common and popular among grocery shoppers.

One of the foremost reasons for this is the concern about contamination. The risk of pesticides and the process of how our meats and vegetables are produced is being closely observed by many. The slightest amount of toxicity in soil can affect plant growth destroying the food's minerals and healthy aspects. This can lead to illness or even death. Animals that are destined to become our consumable meats are also a factor due to how they are raised, fed, and kept healthy. Unfortunately, some have already suffered before the vital information regarding possible contamination is exposed to the public.

In the same way, our religion can be contaminated. Our eyes and ears are

receptors capable of gathering information. At the same time, they are not capable of stopping information from being introduced. A third party must get involved. Our mind needs to play an active part in deciding what to keep and what to throw away.*

A mind that does this in accordance with the Word of God is what the Bible calls a renewed mind.* Battling this infiltration into our religion is a constant struggle. Doubt and unbelief are continually being introduced to our psyche. The purity of our faith in God is attacked by these things.

Once we accept even a tiny bit of contradiction to the Word of God, we are at great risk. The minute specimen that has entered in finds a place to germinate. The devil sows seed.*

*2 Corinthians 10:5, Romans 12:2, Matthew 13:24-43

He wants it to grow within you until it becomes a major part of your constitution choking out the promises God has placed in us. This can affect the way you live and the decisions you make in everyday life.

Many people find themselves in this position today. Something wrong has been engrained into their essential nature and had a direct effect on their personality. Their reactions and emotions are distorted because of the infiltration.

When a mind becomes the devil's playground, the contamination could leach into family members, friends, or those who they meet. Everyone they come in contact with is endangered.

The standard has to be set by the Word of God (the Bible) there has to be ultimate truth.* Once this is established, there has to be at least two or three scripture that will confirm a doctrine or principle to live by. This allows the person to compare the arriving information to the principal Truth

of God's word. If the thought disagrees with the truth, it must be rejected. If it is accepted (especially by repeating it aloud) it carries death with it and will try to produce that into your being.

Everything contrary to the Word of God has an evil mission. It will try to do just what it is designed to do. An acorn will produce an oak tree if it is planted and nourished in the right conditions. It will not and cannot produce anything else.

It is so easy to get lazy about this. Allowing ourselves to continue seeing something wrong or even hearing something evil, when we can avoid it, will do us no good. We must take an active part, when possible, to avoid the voice of the devil. Guard your heart!*

* 2 Peter 1:12, Proverbs 4:23

We will not be able to avoid everything that tries to enter in. Devils and occult practices want us to accept every thought and imagination as our own. We can step back and reflect on what we have heard. Even Jesus went away from the crowd to be alone on occasion.* Time alone gives us the opportunity to look into ourselves to see if there is anything that isn't right. The Holy Spirit within us will help us just as He has promised.*

It is important to remove the things that are holding us back.* Pouring out your heart to God is always a cleansing practice.

Reading the Bible is said to be like looking into a mirror.* When we look into a mirror, we generally are looking to fix whatever isn't right. Reflecting on what has been happening in our lives and looking to see where God has intervened is healthy and produces wholeness in our soul and body.

 * Mark 1:35, John 14:26, Hebrews 12:1

In Bible times, there was the custom of washing feet. In those days, people's feet were less protected and exposed to the dust of the earth more than they are now. Rather than tracking that dust into a home, feet were washed in a basin by a servant. Jesus did this to His disciples.* In doing so, He was showing them how they should be servants to one another. Dust is going to get on the feet from the earth. There is nothing you can do about that, but you can wash it off.

When Peter objected and said to Jesus, "wash all of me then!" Jesus replied," it is enough." We are already clean because we accept Jesus and the work of the cross, but we are still going to get dirty from being here on this earth. We wash our feet and especially those around us through forgiveness and understanding.

*James 1:22-25, John 13:3-5

There are two mindsets. We always have the option to pick one or the other.* They both attach to our soul. One will pull you one way and the other will pull you in the opposite direction. The one that pulls you toward life is Truth. This one will attach itself to the born-again spirit. If there is no born-again spirit both minds will lead to death. We determine how much of our mind will attach to our born-again spirit by believing Truth.

This part of you is recognizable among others and will determine the amount of your person will be in heaven along with your born-again spirit. We are that spirit, but our mind is all we recognize as being "us" at this point. Our flesh will be recreated as new at the resurrection, but our mind is in its renewing stage right now.

*Romans 8:6

The Apostle John tell us to "imitate" good because it is of God and evil is not.* The process of imitation is in our mind and body. He is telling our mind (or our soul) to do this. Our mind chooses what to tolerate, permit, and practice. The renewed mind finds it easier and easier to come into agreement with our born-again spirits.

There are crowns and levels in Heaven. There is also a way in which we suffer loss in Heaven.* If we haven't spent time and energy renewing our mind and walking in the Spirit, we could find ourselves in this minimized position. We may not be as rich there as we could have been. In saying "rich," I mean we are not as recognizable to ourselves as we were on earth. Therefore, our ability to function may be limited as compared to others. But even Paul recognized the comparison of these things on earth cannot be fathomed when it comes to Heaven.*

<center>* 3 John 1:11, 1 Cor. 3:15</center>

We find we are in a place where we need to increase in our identity in Christ. We may have been born again but we failed to continue to identify ourselves with Him on earth. That knowledge never had the opportunity to attach to our spirit which entered heaven.

It is comparable to someone on this earth that isn't really with it. They are not grasping what is going on around them as well as they should. I know in heaven we will continue to grow in Christ. Then again, the best day on earth can never be as great as the worst day in Heaven.*

I'm sure there are many more devices that are used by our adversary. My hope is that these suggestions help the disciples of Christ to be diligent and aware of what is going on around them in other dimensions.

*Romans 8:18, Psalm 84:10-12

www.ingramcontent.com/pod-product-compliance
Lightning Source LLC
Chambersburg PA
CBHW071837210526
45479CB00001B/173